HOXTON MINI PRESS

We are an indie publisher from East London
who make collectable photography books.
We should probably tell you how great
we are but actually we spend a lot of time
feeling anxious, lost and having bad ideas.
That's because we believe that to do something
well you have to risk doing something badly.
Creativity is about mistakes, editing, exploring
and trying again. It's definitely not about being
perfect. That's why we've worked for three
years, with multiple failed attempts, to make
the very best notebook we can... so that
you can let loose. Be yourself.

*Ann and Martin*
Hackney, London

'You can only go forward by making mistakes.'
*Alexander McQueen*

'When I was young, I observed that nine
out of ten things I did were failures.
So I did ten times more work.'
*George Bernard Shaw*

'Creativity is allowing yourself to make mistakes.
Art is knowing which ones to keep.'
*Scott Adams*

'A person who never made a mistake
never tried anything new.'
*Albert Einstein*

'Failure is so important. We speak about success all
the time. It is the ability to resist failure or use failure
that often leads to greater success. I've met people
who don't want to try for fear of failing.'
*J. K. Rowling*

'Whether you succeed or not is irrelevant,
there is no such thing. Making your unknown
known is the important thing.'
*Georgia O'Keeffe*

'Success is not final, failure is not fatal: it is
the courage to continue that counts.'
*Winston Churchill*

'The worst enemy to creativity is self-doubt.'
*Sylvia Plath*

'Our greatest weakness lies in giving up.
The most certain way to succeed is always
to try just one more time.'
*Thomas A. Edison*